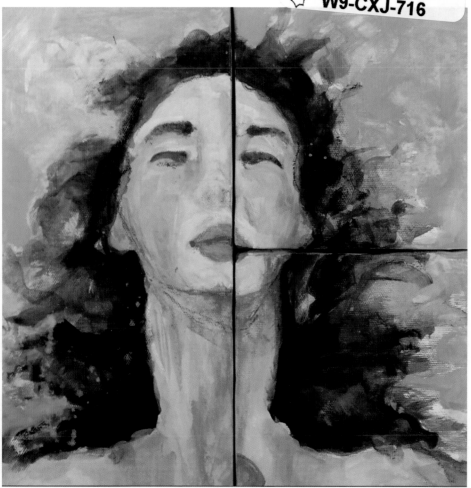

Acrylic on canvas by Maurya MacDonald

Published by

benton **buckley books**
be bold.

www.bentonbuckleybooks.com

Principal Publisher: Beth Buckley
Graphics: Erica Core
Editors: Beth Buckley & Erica Core

PUBLISHER'S DATA

Equal & Empowered
Essay, Poems, and Art Inspired by Feminism: By Young Students
Around the World

Members:
Caitlen Macias, Eva Oliveri, Andrea Lacher, Katie Berlatsky,
Sigi Macias, Victoria Gallastegui, & Riley Coyne

Library of Congress Cataloging-in-Publication Data
has been applied for.
ISBN: 978-0-9994818-4-4

For information about custom editions, special sales, or premium
and corporate books, please contact benton buckley books at
bebold@bentonbuckleybooks.com.

First Printing 2018
10 9 8 7 6 5 4 3 2 1

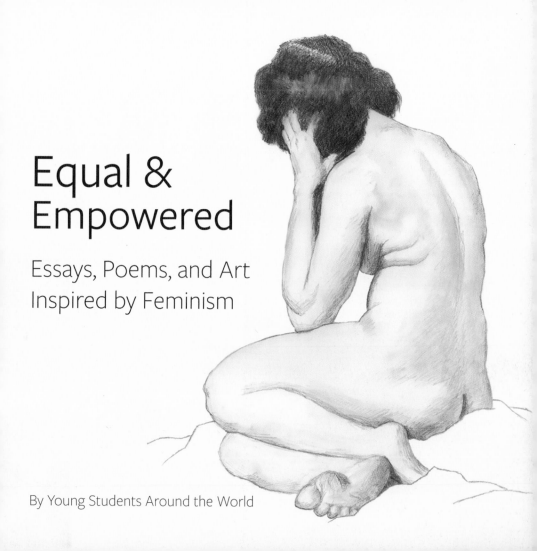

Equal &
Empowered

Essays, Poems, and Art
Inspired by Feminism

By Young Students Around the World

E qual and Empowered began in response to an obstacle I and many others face: gender-based discrimination. Personal experience and research on feminist issues brought me to a point where I could no longer be a bystander in my own life. I fused my frustration, anger, and pain to create an idea. What if we put our energy into empowering and educating young people about feminism? If we can generate so much hatred for difference, why not utilize our differences and perspectives as a source of power. Let's use our stories and our voices to find solidarity and spread positivity. I took the idea—to educate and empower—and pitched it to a group of peers at my school. Students became interested, sharing their own stories, opinions, and plans, crystalizing in the creation of Equal and Empowered.

The group sought to inspire, educate, and raise awareness about issues faced by women and other marginalized groups. To educate students we held a convocation to highlight the inequality people across the world endure. We were presented an opportunity, through our school, to expand our reach. Palm Beach Philanthropy Tank, an organization dedicated to equipping the youth—or as they like to call us, Positively Disruptive CHANGEmakers—with the resources necessary to invoke much-needed change in our communities and around the world, hosted a competition aimed at supporting breakthrough student initiatives.

It was a great honor to be selected as finalists in this competition and take the stage to introduce our cause. I can still remember the empowerment I felt sharing my story. I told of the pain I felt when I was bullied based on gender, and the frustration I experienced when I witnessed injustices committed against others on the basis of gender, race, and ability. We shared our vision to transform pain, frustration, difference, and apathy into positive action. Starting E&E was the seed that we hoped would bloom to inspire and motivate others to join the movement towards equality for all. We left the stage with tears in our eyes and hope in our hearts. Through this victory, we were honored to secure motivational mentorship from philanthropist Julie Fisher Cummings and other courageous women who committed to guide us on this journey, and for that, we are grateful. In addition, Philanthropy Tank provided a monetary award, which facilitated the creation of this book.

How Equal & Empowered Started

by Caitlen Macias and Sigi Macias

Our vision was no longer just a dream, it was the beginning of a reality. Equal and Empowered embarked on a journey that would not only change the lives of the group members, but include others from different perspectives beyond our local community. We began to spread our message—first locally, and eventually, internationally. Our logic was and still is: if you change and empower enough communities, you change the world.

After months of mentoring and meetings, we were elated to see that our efforts were beginning to change the mindsets of many students. E&E was fulfilling its purpose, however, we still dreamed of creating something that was tangible and would reach a larger audience. Something that would last throughout time and be part of a legacy of individuals speaking out and choosing to uplift others. With empowerment in mind, we chose to curate a book. The members envisioned the book to be filled with the diverse voices of youth who believe everyone deserves to be treated equally.

We began promoting our idea; we reached out across the globe and asked for young people from all walks of life to submit their stories, poems, and artwork inspired by feminism. We were overwhelmed and inspired by the responses we received. This book represents a compilation of some of the moving submissions. The work that adorns these pages comes from students residing in Panama, Honduras, and the United States and embodies a range of topics including fragile masculinity, gender roles, lack of LGBTQ representation in schools, and other forms of inequality.

It is our hope and intention that this book will instill in everyone a sense of solidarity and empowerment. One person, one voice, can ignite the flame to start a movement.

"Words are a form of action, capable of influencing change. Their articulation represents a complete, lived experience." ~ Ingrid Bengis

This is a remarkable high school generation that wants action now and has little tolerance for the status quo because it's too hard to change. We have seen their successful and strategic actions around gun control, sexual harassment, and police brutality. Teenage students today have said "enough is enough" in many different forums. It is in this context that Equal & Empowered is launched. After winning a competitive grant process, these young women editors and leaders set about creating a publication to reverse sexism. And ALL isms! This publication is the fruition of their commitment and passion for a better, more just world.

As one of the adult advisors to this project, I have been privileged to witness the energy, passion, creativity, and insights of these young women. The writings that follow will inspire, challenge, and motivate you to join them in making our communities better places for all. Thankfully, our collective future is in the wonderful hands of these philanthropists, writers, and leaders.

We are fortunate to have them as our visionaries...for they envision a world where...
"All humanity is one entity." ~ Marjorie S. Fisher

With respect,
Julie Fisher Cummings MSSW
Founder and Chair, Lovelight Foundation

Foreword

Introduction

The human story has multiple authors, numerous settings, and diverse morals. Across time, societies and individuals have lived in peace, suffered under oppression, or experienced a mixture of both privilege and injustice. Anthropologists research our human story as told through our behavior. Poets give voice to it, artists interpret it, but all of us experience that story as both a main character and as an element of our time and culture.

As a function of our time and culture, the idea for this book originated with a group of exceptional young women who attended our school in Boca Raton, Florida. Each had experienced, or had observed, injustice in some form or another and wanted to do something about it. Since our school mission rests firmly in creating voice and a personalized curriculum, they were encouraged to follow this passion. We hoped not to get in their way.

The learning path involved researching and reflecting about concepts of feminism, equality, justice, equity, power, and the real task of change agency. The best projects for learning include both success and failure, recognizing that the latter is actually what propels the deepest learning. Passion, talent, determination, and a good idea still encounter obstacles. Conquering those obstacles paves the way for an initiative with broader impact.

This work represents not one story, not one concept, not one ideal. This work helped me to personally sort out my feelings about feminism and social change. Turning each page, seeing each name, I feel intense gratitude to the young women who started this journey, the young men and women who joined them along the way, as well as the not-as-young, but truly instrumental, men and women of Palm Beach Philanthropy Tank, *benton buckley books*, and all of the students from Grandview Preparatory School and around the world who contributed their work.

"I raise up my voice—not so I can shout, but so that those without a voice can be heard...we cannot succeed when half of us are held back." ~ Malala Yousafzai

Jacqueline Westerfield
Headmistress, Grandview Preparatory School

THE STIGMA SURROUNDING FEMINISM
by Victoria Gallastegui

Feminism
noun
> *The theory of the political, economic, and social equality of the sexes.*

Yes. This is the definition of feminism, and this is the feminism that Equal + Empowered, as well as most feminists, fight in the name of. A large portion of society, however, does not see feminism in this way. The above definition is the official definition taken from Merriam-Webster, but compare it to Urban Dictionary, a site managed by regular people, and you will find something entirely different. The top definition of feminism (as of March 5, 2018) in Urban Dictionary is as follows: "The biggest disgrace to my gender. Feminism used to be about women getting the same rights as men, such as the right to vote and equal pay at work. Now feminism is a movement full of women who seem to think that their ability to push a baby out of their vagina entitles them to bigger and better everything."
That's not all. The next 21 are similar, or far worse, and after the 22nd, negative definitions continue to dominate, with recurring themes before the neutral definition such as:

> 1. Feminism is based on false ideals.

> 2. Feminists want women to be superior to men/ hate men.

> 3. Feminists are ugly complainers and are only feminists because no one loves them.

> 4. Feminism is pointless because men are superior to women and should be.

This is definitely not what feminism is about, and yet, this belief is found not only in the dictionary created by regular people, but is also confirmed with polls done by several organizations, including one done by Huffington Post and Yougov in 2013. The poll revealed that only around 23 percent of women and 16 percent of men consider themselves feminists, yet 82 percent of the survey respondents say they believe that "men and women should be social, political, and economic equals." This number is staggering, as these respondents seemed to agree with feminist ideals, yet did not consider themselves feminists. It can therefore be reasonably inferred that a large portion of the population misunderstands what feminism is truly about.

Feminism is about fighting for equality for everyone, so that people of every gender, race, sexual orientation, ability, religion, ethnicity, socioeconomic class, and belief would be considered equal socially and politically.

FALSE FEMINISTS

There are several factors that cause society to believe feminism to be something it is not, and is often fighting against. A large portion of blame could be placed on those who identify as feminists and yet promote ideas that are directly contradictory to the very definition of feminism. These "feminists" are actually misandrists, "white feminists," "social media feminists," or otherwise discriminatory against any group in any way. These "feminists," though in the minority, are often the loud promoters of their brand of feminism, and so are what society sees as the face of the feminist movement. This is further encouraged by anti-feminists who use prejudiced "feminists" as ammunition against actual feminists who fight for complete equality. This causes society to view feminism as something it is not; an excuse to complain, belittle men, and fight for superiority. This is a serious problem for the feminist movement as it undermines the movement's credibility. The groups and individuals who undermine feminism while posing as feminists may be described as "false feminists."

Misandry

Misandry is defined by Merriam-Webster as "a hatred of men" and this is exactly what misandrists posing as feminists promote. Misandrists believe that men are inferior, and should be treated as such, which is against the very heart of feminism. Misandrists generalize and are prejudiced against men, as well as promote the superiority of women, while posing as feminists, causing others to believe that feminism is about pushing men down to elevate women above them (example 2). Men see and hear what misandrists pretending to be feminists say and do, making them hate feminism—a movement dedicated to equal rights for women and men, and a promoter of both men's rights and women's rights.

Feminism, in comparison, is defined by equality of the sexes, and is certainly not against men. Feminists believe in complete equality, on both sides, and understand that women have certain advantages given to them by society, just as men have certain advantages as well. Feminists do not hate men, nor do they hate masculinity; they only hate the confines of toxic masculinity (the idea that a man must act a certain way such as not showing emotion, only wanting sexual intercourse, and other limiting or harmful expectations). Feminists fight against the idea that men and women must act a certain way, like certain things, and have certain skills because of their gender, and instead believe that everyone should feel free to be who they want to be (as long as they are not hurting others).

WHITE FEMINISM AND OTHER PREJUDICED DISTORTIONS OF FEMINISM

No, not all feminists who are white are White Feminists. White Feminism is a distortion of feminism which focuses solely on the issues that white women (and usually neurotypical, cis-gendered, straight, middle-upper class women) face, and ignores the problems that all other groups face. White Feminism and other similar distortions of feminism undermine the feminist movement by excluding minorities and making it seem as if the feminist movement only fights for the interests of a particular group, rather than for equality for all.

Feminists fight for the rights of all individuals, and seek to establish complete equality around the world socially, politically, and economically. Complete equality does not mean "sameness," as each individual is unique; instead, it means that every individual has equal access to opportunities to succeed and is treated equally by society without constraints of social expectations set by gender, sexuality, ability, ethnicity, and other categories. Anyone who believes that everyone should be equal is a feminist, in its truest sense, even though White Feminists and other False Feminists have attempted to twist the word to suit their needs. Feminism is still a movement intent on bringing complete equality to the world. Feminists fight for the rights of all those who do not have them.

SOCIAL MEDIA FEMINISM

Not all feminists on social media are Social Media Feminists. Social Media Feminism is a brand of false feminism in which the "feminist" reposts and shares feminist, misandrist, and white-feminist views and information indiscriminately on social media without truly understanding what any of it means, or perhaps not caring, and simply wanting to use feminism to increase their own popularity. Social Media Feminists often promote ideas that are harmful to feminism without truly realizing it. They blur the lines between other "false feminists" and true feminism.

Instead of fighting for what matters with logic and factual evidence (example 1), they use feminism as a means to justify useless complaining and whining (example 3). As social media feminists are very active, the public believes that all or most feminists are like social media feminists who cannot defend their argument with sound logic and simply resort to name-calling, complaining, and placing blame on others. They also undermine the feminist movement by encouraging misandrist and other prejudiced distortions of feminism, thus giving opponents perfect ammunition to weaken the feminist cause.

ENDING THE STIGMA

The stigma against feminism is severely limiting and is undermining the goals of the movement, making it harder for progress to be achieved. Because of Fake Feminists, a large portion of the population believes that feminism is fighting for the superiority of women, when this is certainly not true as it even goes against the meaning of the word itself. This portion of the population may believe in equality and in feminist ideals, but would never call themselves feminists, causing the feminist movement to lose vital support even from those who believe in their goals. Because of the stigma around feminism, conversations on equality and the actual goals of feminism are often dismissed as soon as the word "feminism" is uttered because of the negative connotation of the word. This severely damages the chances of the movement for making actual, lasting change on society. Education and discussions held on what feminism really means and what feminists fight for will help increase support and allow for progress to be made as conversations can be held without the immediate dismissal of feminist ideals. One of the reasons for the production and distribution of this book is to help to reduce the stigma surrounding feminism and to promote feminism and equality. Without the stigma surrounding feminism, feminist goals will likely be achieved far sooner, and complete equality may soon become a reality.

In thinking of how to write this chapter, I have to admit, I was conflicted about how to approach this topic. On the one hand, I am a woman in America who is considered to be a high-functioning autistic individual. On the other hand, I grew up with backlash for those same qualities, and witnessed both sexism and ableism alike, particularly in school environments. While I cannot speak for everyone with autism who identifies as female, I acknowledge that I am privileged to be able to express my feelings in this book, and hope that in doing so I can shed light on the familiar feelings of alienation that women on the spectrum have also felt. The inclusion of women with mental disorders, otherwise known as being neurodivergent, is something that I believe is vitally important in the discussion of feminism and the future of equality for all women.

What does it mean to be a woman? That's already a hard question to answer because as a society we already know the answer we've been given by those who push us out of our own narrative. To be a woman in the eyes of this society, unfortunately, means to be plastered on billboards and in magazines and objectified. It means to be silenced by our husbands and the men who we raised and cared for and loved, it means to be talked down to and deemed unfit for conversations directly involving your own mental and physical health. It means to be treated as a nuisance in your own conversation, as something both sought after and rejected at the same time. Growing up, as many other women with autism have felt, I felt as though I was failing to meet the stringent expectations of my gender: by not being conventionally ladylike, by being loud, boisterous, and talkative, full to the brim with words, and words, and more words that could never piece together the swirling vortex of feelings and frustrations that I felt. Translating these feelings to my neurotypical educators and classmates was a daunting and recurring struggle. I was told that wasn't how I should be, that I had to control my voice, my temper, my heart, and eventually to silence it to let others speak for me, over me, through me. And yet, the young boys in my class who behaved the same way as I did were treated in a much more positive and forgiving light. What would make me appear inappropriate made them the class clown. What made me hyperactive made them charming. What made me autistic made them the voice you heard in autistic discussions, since boys are incorrectly supposed to be the only gender on the autism spectrum.

The Feminine Spectrum

by Andrea Lacher

Of course, it would be unfair to say that men and boys with autism do not also struggle, just as I and other women have on the spectrum. But it is just as unfair that neurodivergent or physically disabled women are always being erased from the narrative of feminism and the struggle for equality in favor of neurotypical and able-bodied voices. We have a responsibility to help those with disorders struggling to navigate an unaccommodating and ableist world, to give a voice to those girls who were silenced while their male classmates were listened to, to love those who deserve to be loved for who they are, not for who they are not by neurotypical standards. And yet, the way that we discuss people who are neurodivergent both online and in the real world is appalling, and this ableism is often neglected entirely despite being constantly present. We use slurs and abusive speech to make them feel more isolated, more alienated from the world that they, also, contribute to immensely. In the medical world, women are more likely to not be diagnosed correctly with autism compared to men. If you are a woman who does not fit into conforming stereotypes of femininity, then just imagine also being a lady who stims, who has vocal ticks, who is hyperactive, who has violent tendencies and meltdowns, and for whom these symptoms remain undiagnosed and unaccommodated for, because we have conditioned ourselves to believe that the woman who expresses her distress does not count as what it means to be a woman.

I believe that I count as a woman, regardless of what girls like me have been told and taught and lied to about our identities and self worth. Neurodivergent and autistic women are important participants in the conversations we have about feminism and when we fight for equality, we need to be fighting for their equality as well. It is our job, as a new generation of conscientious social activists, to help those who have been left to be abused and forgotten in past generations, and to give them a voice; one that can finally be understood as women on the feminine spectrum of autism.

Caitlen Macias is a student studying at The College of William and Mary. As a feminist she hopes to educate and raise awareness on feminist issues through this piece and through Equal and Empowered.

ON WE MARCH

We chant, we stand together
All birds who share feathers

Holding signs to protest
Keep marching don't rest

Pink hats in the crowd
In the silence we are loud

Around the world we stand
Equality we demand

United not divided
With love, we are guided

Caitlen Macias

SELF-ESTEEM

We're told to embrace our flaws
So often it seems cliché
The kind words are spoken
but never put into play
Walk with your head down
because every look is judging
Stay quiet, silent
You know it's for the best
Try as you might, you're just not like
the rest
Words can be painful,
Cause tears and red lines
But the biggest critic is always the one in your mind.

We are taught so much about the perception of others, but self-love is arguably the most difficult and most important aspect of one's self-esteem. It is okay not to be okay and that is something society still struggles with accepting.

Andrea Lacher

Andrea Lacher is a college student attending the Savannah College of Art and Design to study animation. Andrea chose to create her piece because she felt that it was important to her, and with the experiences she has had, and how often in discussions of feminism women who have mental disorders or mental illnesses are often forgotten. She wanted to discuss the experience that comes with being a woman, and how that affects both her and others around her. This piece is a feeling women are all too familiar with—being at odds with yourself, constantly doubting if you are behaving as is expected of you and of your gender, and the pressure to conform to traits that disregard your own mental health or well-being. In discussing feminism, it is vital that we discuss the disabled community in feminism, the women of color in feminism, and the overall feminism of nonconformity and not being "ladylike" as society enforces.

Victoria and Riley are both students in the 11th grade at Grandview Preparatory School. They are both members of Equal and Empowered and are passionate about education about feminism and equality. Both Victoria and Riley thoroughly enjoy Harry Potter, the Flash, reading, and music.

Riley Coyne

Victoria Gallastegui

Twice upon a time there was a girl and her grandmother in the year 2077. This granddaughter/grandmother duo was a wonderful mesh of old and new. They were fearless, fierce, feminine warriors facing a world of inequality. This is a glimpse of their story.

Amber

The sun sunk beneath the waves, painting the sky with the colors of flames; beautiful crimson and warm orange disrupted by small patches of brilliant white. The light shadowed the planes of a weathered face, making the woman appear even older. Her eyes were full of sorrow as she gazed out at the pounding waves. She reflected on her life, the life of Amber Rose Carter. She reminisced of her best memories and was filled with pride of what she had accomplished. A pang of regret shot through her as she thought of what she had yet to do, what she would never be able to do. Amber felt a hand wrap around hers gently, smooth while hers were wrinkled, and turned to smile sadly at her granddaughter, Flora. As always, she felt startled by how similar Flora looked like her when she was younger, so many years ago. She had the same fiery spirit that Amber had once possessed. Age and exhaustion from her cancer had all but extinguished that flame. For a moment, she wondered if the years would claim her granddaughter's fire too, but she quickly dismissed the thought, knowing that Flora was even stronger than Amber ever was.

Tears rolled down her lined face as she came to the realization that she would never see her granddaughter get married, never see her have a family of her own, all because of this accursed disease. She steeled herself before beginning to speak through the lump in her throat, "I called you out here because I need to tell you something; something important."

"What is it, Nonna?" Flora asked softly, placing her other hand comfortingly above their intertwined fingers.

"I- I'm dying, Flora," Amber replied bluntly. Flora's eyes widened in shock and her grip on Amber's hand tightened painfully. An inhuman noise escaped her throat as the color drained from her face.

"What? How? Why?" Flora stammered in confusion.

Amber took a deep breath, her chest constricting painfully. "I have less than a month," she whispered.

Tears collected in Flora's eyes and trickled down her face. "But w-why?" Flora stammered, the pain in her eyes unbearable to look at.

Amber turned away, tears dripping down her face. She did not know for how long she would be able to walk, to act like herself. A stab of pain, of denial, ripped through her. Her throat burned as she replied, "I have cancer."

Flora seemed to struggle with this new information for a moment, and the hope in her voice sounded forced as she murmured, "There are so many experimental treatments..."

Amber turned back to her granddaughter and shook her head. "No Flora, I've tried them, they won't work and I don't want to die suffering more than I have to," Amber spoke with finality, her gaze firm and unyielding.

"You can't just give up! There has to be something! How am I going to live without you?" Flora's voice cracked painfully.

A genuine smile spread across Amber's haggard features as she spoke softly, "Oh Flora, I have no doubt that you will succeed, you don't need me for that."

"No Nonna, I do need you! You've taught me so much, but I still have so much to learn from you!" Flora insisted.

"And I have much to tell you, that's why I called you out here," Amber replied patiently.

Flora struggled for a moment more before replying, "Where do we start?"

Flora

After the gut-wrenching news that was Nonna's cancer, Flora took a stroll down the beach to wrap her head around things. Her body shook as she tried to push away the sorrow threatening to crush her. Then anger took its place, soaring through her body like flame. "This isn't fair!" she shouted at the waves, as if they could do anything about it, "We are supposed to have years more worth of memories!" In a quieter voice she murmured, her voice breaking, "It just isn't fair."

As the sun sunk beneath the waves, Flora walked in the surf, processing what her Nonna had just said to her. She tried to just focus on walking, the moist sand squishing in between her toes. She felt her eyes pooling tears, then overflowing and streaming down her cheeks. The only question that continued to pop into her head was, why?

Flora felt like a zombie walking through the school halls the next day. That morning she had begged and pleaded with her mother to stay home and spend the day with Nonna, but her mother thought that keeping things as close to normal as possible would be a better way to cope. So instead Flora finally snapped out of her trance when the closest thing she had to a best friend, Georgie, called, "Hey Flor!" as she ran up to give her a hug. Then, noticing the look on Flora face, she asked, "Wait, what's wrong?"

"Nothing." Flora replied quickly and hurried into the girls bathroom that happened to be to her right.

"What do you mean, nothing. Obviously something's going on," Georgie said in an exasperated tone, following her friend inside.

"I just don't want to talk about it," Flora murmured painfully, turning away to stare at the sink, wishing she could just vanish and leave her sadness behind.

"I'm your best friend, you know you can tell me anything," Georgie said, placing a comforting hand on her shoulder.

"Well...," she hesitated, "do you remember my grandmother, Nonna? I think you met her at the spring music concert."

"Yes, I remember. What's the matter, did something happen to her?"

"Yeah, kind of. Last night she told me that... she told me... that," Flora paused and took a deep breath before attempting to continue. "That she is going to die of cancer," Flora finished quickly.

A look of shock passed across her face before she rushed forward to envelop her best friend into a hug. "I'm so sorry, Flor," she murmured. Suddenly, a loud flush made the two friends jump apart and stare at the stall from which the sound came from. Somehow, in spite of herself, Flora began to laugh, and so did Georgie, and everything did not seem so dark and gloomy anymore. And for the first time since hearing the terrible news, Flora felt light.

Later, while Flora was at home struggling through a Chemistry packet that was due the next day, she heard a knock at the door.

"I'll get it!" Flora exclaimed, bounding down the stairs to open the door. On the other side she found the familiar sight of her grandmother's smiling face.

"Let's take a walk," Nonna said to Flora.

Amber
Amber walked slowly, taking in the beautiful scenery and the feel of the sand between her toes. She thought back to where it had all began, to where she became who she was today.

Her smile faded at the memory, and she turned to her granddaughter with a faraway look in her eye. "I suppose it all started when I was sixteen," Amber began, feeling the beach and the present slip away.

● ● ●

Amber was sixteen; young and carefree. She had invited her closest friends over for a small get-together at her house and was truly enjoying herself. She was laughing at one of her best friend's classic bad jokes when her family friend, Jen, cried out in shock.

"Guys, guys, you need to see this," Jen told them in alarm. The panic in her voice made Amber's stomach drop.

"What is it?" Amber's best friend, Olivia, asked urgently as the group of three made their way as quickly as they could over to Jen, who was holding her cell phone in a white knuckled grip. "Turn up the volume, Jen," Olivia told her impatiently and Jen obliged, though they all wish she hadn't.

"-Chants of 'Blood and Soil' are heard from these demonstrators on their march to protest the removal of Robert E Lee, a confederate general," the newscaster began, and the video of her speaking was replaced by a video of a group of people marching, "As you can see, they seem to be carrying flaming torches. Thus far no violence has been reported, and we will continue to cover this story as more information becomes available. We will be back after this short break."

They all sat in silence for a while, wearing varying degrees of shock, confusion, and in Jen's case, horror.

"What was that?" Olivia asked, shifting uneasily, "What does blood and soil even mean?" Jen turned to Olivia with deep sorrow in her eyes, explaining, "It's a Nazi slogan. It was an ideology about how ethnicity was based on blood descent and the land you have and use. It idealized farmers and peasants, while blaming the urban people who had more money and

made them out as the villains. It was used to help the Nazi Party blame Jewish people for the decline of Germany because they painted German Jews as rich merchants."

Amber felt as if the ground was falling from beneath her. She could not understand how people could be so hateful so many years after everyone was supposed to learn that it was wrong. She could not understand how someone could think they were better than someone else because of their heritage, religion, or really any other factor. She could barely process the fact that these people not only existed, but they felt so powerful and comfortable in their own prejudice that they would go out in public and show everyone else just how bigoted they were.

Amber thought about all that had happened in the past few months, and suddenly, she felt as if she should have seen it coming. All the hate had been building up, like a pot ready to boil over, so it was really only a matter of time until the hostility would leak over the edge. She turned towards Jen, feeling something heavy in her chest. She could not fathom how it felt to be Jewish hearing this news, but judging by the frightened look on her face, Amber could guess.

She felt anger rise through her and an ache to do something. She felt she needed to stop it. Somehow, she needed to fix it. But how? That was the question, wasn't it? But she would not let her feelings go; not when she felt so strongly about them, not when she knew her friends, the people she cared about, would be suffering because of this. She needed to do something to stop this, to take away the fear in her friend's eyes, to make her home the place where she and everyone else felt safe. A sudden clarity seemed to soar through her and she stood, feeling as if there was only one thing left to do.

"I don't understand why these people are acting this way, but I do know something. I know that we can try our best to stop it. We have to do something," Amber said firmly, looking at her friends eagerly, waiting for them to agree.

Olivia nodded slowly before replying thoughtfully, "You know, I heard they're starting an equality group at school, why don't we join?"

Jen nodded at Olivia and turned to Amber who smiled, saying, "Let's help make a change."

When school started once more, the three friends joined the equality group Olivia had mentioned. As the years progressed, they continued to join groups and movements, eventually traveling for marches and demonstrations. Even as they went to different universities, they continued to fight for equality not only in the United States, but around the world. By the time Amber held her grandchild, Flora, in her arms, she had been part of several movements, numerous protests, and several organizations. She had worked hard to achieve true equality, and although she would soon be leaving her granddaughter behind, she had also left her a brighter world, a fairer world. There was still work to be done to truly fix society, but the world had advanced so much in those sixty years. She knew she could trust her granddaughter to carry out her dream, so that maybe one day, she would see a world without prejudice and discrimination. One day, she might see an equal world.

THE END

Sigi Macias

Sigi Macias is a junior at Grandview Preparatory School. She likes to dance, sing, and catch cats.

Disrespect the way I dress
Walking down these halls
Calling me a hot mess
You make me make calls
To my parents, it's apparent
You don't like my pink top
With a little piece of transparent
That I liked at the shop.

I'm taking the blame,
And am feeling shame
Because boys will be boys
And women are just their toys.
Well no more of this mess
It shouldn't matter how I dress
I deserve respect and more
For what I pick out of my drawer.

I try but it is not enough
I fight but it is not enough
My entire gender is placed into a box which is not enough
Because to those who seek to define my place in this world
I will never be enough

And as I read stories of our progress
I feel proud of how far we have come
But when I get shut down, harassed, shamed, cat-called,
I realize that our progress is what's not enough

So we must keep pushing until the glass ceiling is broken
We must keep pushing until we are more than enough
And, eventually, when we reach the point of true equality
We can yell with pride
And this time we'll be heard

Emily Kramer is a proud feminist and high school student at
Alexander W. Dreyfoos School of the Arts.

Emily Kramer

if you
keep a bird in her
cage for long enough,
she will begin
to believe
she belongs
there.

Archi Patel is 15 and lives in South Florida. Apart from her passion for painting, she enjoys reading, photography, running, and calligraphy. She created this painting to express a feministic message. The painting is an abstract view of mountains and a silhouette of a bird. The bird represents freedom. Archi wrote in the silhouette: "If you keep a bird in her cage for long enough, she will begin to believe she belongs there." This poetically captures the message in her piece. Sometimes, restraints are placed upon women, impeding them and their beautiful ability to fly.

Katie Berlatsky

A pulse is the beating of a heart echoing in empty veins,
And a pulse is the beating of drums overlaid with rippling music,
Far enough away that you can't quite make out the tune,
And a Pulse is a nightclub where,
On Sunday, June 12th, 2016,
49 men and women were shot and killed for who they loved,
But no,
It wasn't a hate crime.
That idea was rapidly rescinded,
Of course,
When it came out that Mr. Omar Mateen had been to the nightclub before,
His pulse beating in his throat as the music's pulse beat in his ears,
As Pulse was alive even with its killer in its midst.
So because he had been there, before,
It meant that he was gay,
And just hiding it,
Hiding it so much that he was willing to kill 49 of us,
And injure 52.
Stop killing us. Stop killing us. Stop killing us.
But most of all, let us live.
Never mind that most first degree murderers stake out the location where

K. Berlatsky is a 17-year-old lesbian from South Florida, who writes
because the pen is demonstrably mightier than the sword.

They're going to commit their crime.
No, it makes much more sense,
That the gay man did it.
Because that's easy. That's neat.
You can blame us for our own deaths -
And doesn't that sound familiar?
And as if that hatred weren't enough,
As if you're not already choking on it,
Vicious verses acidic in your throats,
Your pulse pounding in your empty ears,
His name is Omar, and so he's part of ISIS,
He says he has no connection, and so he's part of ISIS,
Your god is vengeful, and hates us,
And so his must be, too.
On Sunday, June 12th, 2016,
Was the biggest mass shooting of American history.
But instead of taking any responsibility,
You create the environment in which we are killed and then -
Blame us for it,
Use it as an excuse for your hatred.

THE "F WORD"

It's a bad word
It's a nasty word
It's a crooked word
It's a "How dare you think that you're better than me!" word
It's a dangerous word
The kind of word that sparks change
It's a revolutionary word
It's a derogative word
It's a necessary word
It's a mathematical word
The kind of word that is pseudonymous for equality
It's a hopeful word
It's an educational word
The kind of word that makes people think before they speak
It's a relentless word
It's a strong word
It's an empowering word
It's the kind of word that should spark unity
It's the kind of word that should spark progressiveness
It's the kind of word that should captivate young boys and girls
It's the kind of word the media twists around
It's the kind of word that close-minded people are afraid of.

It's the "F Word"

The "F Word" that is mistaken for a chauvinist
The "F Word" that needs to be shown in gender equality rather
than ranted about in an online blog post.
The "F Word" is not a bad word
Feminism is a good word; for all.

Anuksha Gotmare is currently a high school senior at the Alexander W. Dreyfoos Jr. School of the Arts. She is very involved and informed in politics and her high school's community and has a passion for learning and volunteering. Anuksha chose to create this piece due to the many negative connotations to the word "feminism", and how the whole meaning of the word and the movement itself is for the goal of gender equality.

T.J. is 10 years old and he goes to Grandview Preparatory School.

I think women should be equal with men because it's wrong for all people to be at different paying jobs because of their gender.

T.J. Palmer II

"I think that men and women should be equal

because it's only fair if they both have the same rights."

Ana is 9 years old and is in 4th grade at Grandview Preparatory School.

Andrea Lopez

Andrea Lopez is the daughter of Venezuelan immigrants and was born and raised in the United States. In 2010, she moved to Panama with her mom and stepdad and began attending Balboa Academy, an international school in which she was exposed to the many different perspectives of the world. She likes to sociologically analyze gender binaries in her free time, whether it be through conversation or through writing and obsesses over movie soundtracks while she does homework. She also loves popcorn. Andrea will be attending Barnard College of Columbia University in the fall of 2018.

WHY MASCULINITY IS MORE FRAGILE THAN YOUR MOTHER'S VASE

n a world where being queer has gradually become socially acceptable, masculinity seems to have become more fragile than that special vase your mother keeps hidden away in a glass cabinet. Masculinity is so fragile, that a man that shows too much emotion or moves his hands in a certain way can lose his "man card" and/or make him gay. It's something I've seen in my own stepdad, a person that I consider smart and compassionate, yet to him, even the slightest odd movement indicates a lower level of manliness. Masculinity is so fragile that it prevents men from living their life comfortably, doing what they please, for fear of not being "manly enough," which means that masculinity has essentially become a social handicap.

Some men refuse to seek help when they're having mental problems because feelings are too feminine or emotions make you seem gay. This attitude is toxic and is reflected in the lack of men reporting their mental state. Many men have gone mad or taken their lives because of this, and in fact, men commit suicide at a rate nearly four times higher than women but are less likely to seek aid when feeling depressed. Because of this, there has even been a website set up specifically to help men with mental issues by catering to their manliness. A tweet from 2016's post-election buzz says that "progressive males are not men; they move and gesticulate like women. The 'hand-over-mouth' gesture is one example. Physically repulsive." How fragile must masculinity be that someone can't even touch their own face? Fragile enough that making a so-called feminine gesture compromises a man's gender identity. This has actually been noticed by large corporations that pander to men's insecurities on masculinity and capitalize on its fragility.

By taking advantage of men's ego and their need to be non-feminine, businesses like Q-tips create products that appear to be exactly the same as the genderless cotton swabs. However, since the men's packaging features a metallic background, and the words "Men's Ultimate Multi-Tool" they've successfully exploited men's inhibition and profited off of it. This shows the tangible effect that frail masculinity can have on products and markets.

Throughout my life, I have seen my stepdad as a progressive man who has continuously accepted my queer friends as they come in and out of my life. I've seen him interact with them and sometimes even rant about how I should be more of a social butterfly like X friend or how I should volunteer more like Y friend. And this had me convinced that even though most Latin American parents tend to be socially conservative, my stepfather was the exception. I was wrong. As I was talking about how much I enjoyed going to the movies with Z friend, who happened to be a relatively attractive boy, my stepdad teased me about the possibility of dating said boy.

I laughed and continued talking about funny moments from the evening when I briefly mentioned that the boy was bisexual. Immediately, his demeanor changed, and he began by saying that a man that is attracted to other men is not a man, which meant that the possibility of me dating the boy was eliminated. I couldn't comprehend how my stepdad, my wise and loving stepdad, could actually believe that someone's sexuality detracted a person's masculinity and in turn ignored the guy's biology and gender identity just because of the people he likes. It was a difficult reality to accept, but alas, I had to understand that he's from a different generation, one that is less inclusive and accepting and is simply a product of his environment. That's when I realized that no matter how many times someone calls me a "snowflake" or my stepdad thinks I'm too accepting and too sensitive, the real "sensitive snowflakes" in the world are those that feel that gender identity and "manliness" can be determined by your actions, feelings, or the things you buy. And if masculinity can be toppled by such petty things, then the logical conclusion is that it is most definitely more fragile than your mother's precious porcelain vase.

Emma Wilens

Emma is a junior at Grandview Preparatory School.

Talia Kottler

Communications senior at Alexander W. Dreyfoos School of the Arts, Talia Kottler is passionate about writing and spreading thoughts through writing. This poem is about the struggle of equality in high school in everyday life.

My hair, I stroke
I cover my face
Inside, I feel broke
Breathe at a steady pace

Interview preparation
Do I have a chance?
I see a man nation
I stare in a trance

One by one is called
My legs start to shake
I am stalled
I am a woman expected to bake

I did not get the job
I did not get the pay
I am no bob or rob
I am living in a man's day

OVERLOOKED

No one cares about our opinions.
Yet they treat us like minions.
Barking orders at us

Expecting us not to discuss.
Not to stand up for ourselves.
Even though we are told not to dwell
On our past but look well

At how far we've come.
Yet when one of us takes a stand,
They are quick to demand
And call us "feminist"

In a negative tone.
We aren't all that bad,
It's not just some "fad"
We want to be the same
Not just 'some dame'.

Our successes are overshadowed
Thinking our motives are shallow.
Our pride taken away,
Some of us believing we weren't equal, anyway.

This poem deals with feminism and how the word is associated and used most of the time in a negative tone.

Anonymous

Emily Pacenti

Emily Pacenti is a communication arts major at Alexander W. Dreyfoos School of the Arts and has a passion for activism within the LGBT+ community. The theme of this work is about the empowerment and normalization of queer women and the point of view of gay teen girls that are often not represented.

QUEERLEADER

"This is the most cliché crush you've ever had."

"How?"

"Well, she wears short skirts every day and you wear t-shirts... Hey, look we're on the bleachers. It's like if Taylor Swift was a lesbian." Sydney cracks her gum.

"The only reason we're sitting here at all is for your boyfriend."

"I didn't want to wait alone." She pouts, taking the gum from her mouth and sticking it under the metal seat. "Plus, it's giving you an excuse to check out your lady crush."

"What do you think I'm doing at every football game you drag me to?"

"Fair enough, you never do anything but look." She shrugs.

"I can't just ask her out."

"Well, I didn't say that. You at least have to talk to her." She sucks her teeth and uses the hair tie from around her wrist to put her hair up. "And maybe stop wearing so many t-shirts and, you know, wear something that doesn't hide all your assets."

"Assets?"

"Tiff, you keep your cleavage so covered you'd think breasts were illegal!"

"They kinda are, I mean-"

"Yeah, yeah free the nipple. Just free 'em in your crush's direction why don't you?"

"I'm not sure flashing is the most romantic way to get someone."

"It'd at least be creative." She grabs her backpack from by her feet and stands, slinging it over one shoulder and cocking her head towards the field. "Come on. Practice is almost done and I want to say goodbye to Ben before all the cheerleaders do."

"I can't believe you're calling me cliché when you're dating a quarterback."

"He's a running back."

"Is that different?"

"I thought lesbians were supposed to know about sports."

"That's not even the stereotype," I say, taking my backpack and following her down the bleacher steps. "It's just like, I don't know, golf and softball. Football's not even in the picture."

"Whatever, girls never get to play it anyways. Stay here while I say goodbye, the cheer squad's gonna be done in a second. You should say hi when she comes off the field."

"She barely knows who I am."

"Hush, she knows you. She knows me, so she knows you too. Say hi at least." I get a little pat on my shoulder and a half-sarcastic smile before she darts off for a shoulder-padded boyfriend and I'm there, just standing. She'd be fast. The cheerleaders started late anyway, they probably wouldn't finish in time for them to all swarm over before we were gone. I lean back against the bleachers, shut my eyes, and focus on remaining in the background. I'm a post. I'm a solid aluminum post and no one can see me, especially not the cheerleaders, and especially not Carly. I am merely a shadow on a giant metal seating structure for the spectation of sporting events.

"Tiff?"

"Hm?" I open my eyes, expecting Sydney, but there's Carly. Five foot six, blonde hair, 2% body fat, cheer uniform, and star of David necklace Carly.

"Hey!" She grins and sears through my corneas with the whiteness of her teeth, teeth that were unfortunately just like her in the sense that they all seemed, well, perfectly straight. "You're Sydney's friend right?"

"Wha? Oh. Oh yeah. I'm Sydney's friend. Tiffany. That's me, your resident lesbo." My face turns red. Why are gay jokes the first thing I go to and more importantly why are they my default flirting mechanism for presumably straight girls? I laugh at a volume that makes her smile waver and try to think cold thoughts to counteract the blood rushing up to my face.

Think about ice water, or glaciers, or Ice Cube's last album, or Ice-T. God, it's been forever since the last Law & Order SVU episode... Does Carly watch SVU? "What um... Do you, like, need something?"

"Oh, like, um nothing, I just wanted to say hey. Sydney told me I should try and talk to you, I guess she thought we'd hit it off or something." She shrugs and smiles a little. "I don't know. You just kind of had a weird look on your face. I wanted to check to make sure you weren't about to pass out or something."

"Oh um, no I'm fine. I'm just waiting for Sydney to finish saying bye to Hunter." I was actually in the middle of spiritually bonding to the bleachers before my zen was rudely interrupted, but that doesn't seem like something to say out loud. "But um, y-yeah, she uhh..." I swallow the lump in my throat. "She tells me we'd really get along too for, um, some reason. We should hang out sometime."

"Oh great. Are you going to the party tomorrow night?"

No? "Oh. Yeah, yeah, I'm going with Sydney."

"Cool. See you then." She tosses that platinum blonde hair behind her shoulders and waves goodbye before bouncing back to all of her friends on the sidelines. I wait until she's too far to notice, then bolt back down to the player's side of the football field, grabbing Sydney by the wrist and yanking her away from her six-foot-tall, leaky water balloon of testosterone boyfriend. For those interested, the testosterone leaks out in the form of sweat and Axe Body Spray. It's a really fascinating piece of biology, that balloon boy.

"Hey! I wasn't done saying goodbye." She says, taking her hand away and crossing her arms. "What got into you?"

"You told Carly to talk to me?"

"Yeah, I told her she should say hi sometime. You're welcome."

"Jesus Christ, Sydney. I could kill you for this. I was so awkward."

"You've been dying to talk to her." She rolls her eyes and walks off towards the gate to the parking lot. "Come on, we should get going."

"Did you know there was a party tomorrow night?"

"Hm. Oh yeah. Why?"

"She asked if I was going, so I panicked and said yes. Are you invited? I said I was going with you."

"There are no invitations, you just show up. I'll take you, it'll be fine. Maybe you two will hit it off."

"You think?"

"I know." Sydney reaches into her pocket and pulls out her phone, typing something in, then putting it away. "My mom's getting pizza for dinner, let's get back to my place."

• • •

I am convinced that Carly has a superpower. Maybe a lot of superpowers. She seems to have a supernatural ability to just appear at every low point of every school day. Sydney spilled her chocolate milk all over me and her leaky balloon boyfriend during lunch and there was Carly, one table over, to witness it. She walked behind me when I sneezed and banged my head on my locker and she was in my English class when I fell asleep and Mr. Baumann dropped a textbook to wake me up.

"This was the worst day of my life," I say, sprawled out on Sydney's bed while she half does her homework and half texts Hunter on the carpet.

"Sorry about the milk thing."

"Sorry doesn't unstain my outfit today. Now I have to borrow your clothes for the party and your clothes are always too tight."

"You'll be fine. Hey, I wanted to show this thing to you before we get ready to go. Look, it's like a high school dating app, but it's just for girls."

"What?"

"Here, look." Sydney reaches out and I hand her my phone, frowning when she types my password in out of memory.

"I never told you that code you know."

"Oh, hush. Look at this." She opens the app store, does a quick search, and hands it back to me.

"She?"

"Yeah it's like Tinder but for chicks who dig chicks."

"And this is going to help me how?"

"Find all the other Carly's at school. See if they swing your way."

"Do people actually use it?"

"I don't know, just make an account and see. That gay cousin I have swears by it."

If Carly wasn't straight, would she have an account? "Can you search people's names?"

"I think so."

"Okay." It only takes a minute to make an account, but I don't put my name or photo yet. It kind of sounds like an app that people just get outed on, but if other girls from school were on there...

"Is she on there?"

"Hold up, I'm checking." The app lets you search by school, so I go there first, then go to type her name. By the time I'd finished typing just Carly, her profile came up. There was a picture of her and she was in her cheer uniform with her hair tied into a ponytail so tight that it could have functioned as botox. "Oh my God."

"What?"

"She's on this."

"She is?!" Sydney nearly trips out of the desk chair, rushing over to me, and taking the phone from my hands. "No way, no way, no way. Oh my God. Carly Shea is a lesbian oh my God. I think the world is ending or something."

"Hey, you were the one that said I should go for this."

"Well, evidently I was right." She tosses the phone back on the bed. "Don't let her know you saw it. Don't like it or comment on it or anything."

"What? Why? This is like my only chance."

"No it's not, now you're probably like the only person who knows. Make a move on her at the party tonight, that's your shot."

"No way, all those people will be there."

"You have to pull her aside, dummy. Invite her upstairs."

"Upstairs?"

"Yes, upstairs. Now get up. If you're doing this tonight, then I'm doing your make up."

· · ·

"I'm having a panic attack."

"You're not having a panic attack."

"I'm having a panic attack."

"Just come inside." Sydney sighs, grabbing me by the arm and tugging me towards a large oak front door. The handle looks like it's vibrating from the music inside and the conversation sounds so loud even from the front porch that it feels like the entire high school is inside.

"Look, you have to find her right away and just do your thing. That way you won't worry about it the whole night."

"This feels like a suicide mission."

"Don't be so dramatic." Sydney rings the doorbell and we both take a step back. "Look it'll be fine, you look..." She scans my outfit. "You uh, you look kinda good."

"Kinda?"

"Hey! You guys came!" Carly grins from a now-open doorway, other partygoers flowing behind her into an ebbing sea of red Solo cups. "Come in, come in!"

"Yeah uhh hi!" I follow Sydney inside and feel my chest tighten when the front door shuts behind us. Everything is loud and every room is crowded, the floor is vibrating with the sound of the music as if someone took the bass knob and just cranked it to ten.

"Hey Carly, Tiff's never been to your house before!" Sydney shouts over the deafening sound of Y100 radio. "You should show her around!"

"Oh! Yeah totally! Come on, I'll give you a tour!" Carly grins, grabbing me by the wrist and tugging me out of the foyer, into the adjoining living room. I think it has to be another one of her superpowers, I'm not sure how she moves through the crowd so easily, but the Red Solo Cup Sea seems to part before her and she takes me all the way to the kitchen. It's a little quieter there, just a handful of people grabbing snacks and pouring drinks, but the floor is still vibrating. Maybe I should just get it over with. Be casual about it. Just do it to get Sydney off my back if nothing else.

"So this is the kitchen, we just had it redone in May, but it's going to get totally trashed tonight." Carly shrugs, hopping up on the counter and crossing her legs.

"Yeah, um it's nice. Really nice... Hey, funny story."

"Hm?"

"Have you uh... you know um, heard of that app? It's called She."

"She?" Carly looks away. Maybe Sydney was right after all, she seems embarrassed.

"Yeah, I um... I-I was on it and I saw your profile and I thought um... I-I don't know, I just thought maybe we could see a movie sometime or something?"

"Oh... Oh, Tiffany, no, no, I'm sorry. My uh, my friends made that account as a joke. I thought I deleted it." She said, biting on her lower lip.

"Oh." So this is the end of the world. This is what it feels like. The apocalypse, the end of days, this is what it's like. "Uh, that's cool! That's funny. Really funny." I shrug as blood rushes from every corner of my body up to my cheeks. "Hey, I'm gonna go find Sydney, thanks for, um, showing me the kitchen. I'll see you later."

"No problem. Sorry for the mix-up." She says with a cute guilty look on her face that only makes me want to punch Sydney more for making this happen. I make my way out of the kitchen, back through the living room, until I find her sitting on the arm of the sofa.

"We're leaving and I'm going to kill you."

"What? Why what happened?"

"The profile wasn't real, her friends made it. Now take me home, you're my ride."

"But we just got heeeeere."

"We're leaving." I take her by the arm and pull her back to the foyer, then out the door. "I can't believe you made me do that."

"Do what?"

"I asked her out!" I exclaimed, giving Sydney a well-earned kick in the shin. "You're so stupid, now I need to, like, transfer schools and leave the country."

"Oh," Sydney says, shrugging. "Sorry?"

"Yeah. Sorry." I sigh. "Just take me home."

Sofia Grosso

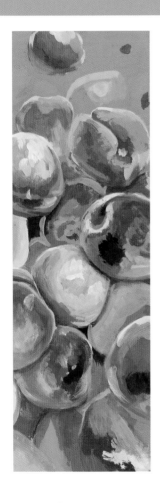

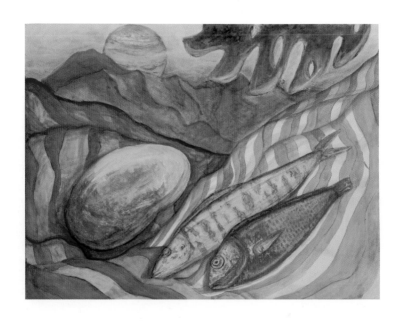

Sofia Grosso is an artist based out of South Florida, currently focusing on conveying the themes of violence, consumerism, and feminism in her work through an emphasis on color, form, and fruit. This piece particularly illustrates these themes; the peaches are rendered with fleshier, more bruised tones to indicate the violence that is inherent to cultivation of food.

I PLAY LIKE A GIRL

I want to travel the world.

You can't, you're a girl.

I want to see things I can't marvel in by staying in one place.
I wish I could have the world.

You think like a girl.
You play like a girl.

I want to make a change.
Through theatre, singing, dancing, loving, having conversations.

Don't be girly.

I want to let myself open up to those that refuse to open up to me.
I wish I could change just one mind.
But of course, as a woman, I am objectified if I make my voice heard.

She's playing the woman's card.
Enough!
I can do *just* as much as you can.
I can travel to far-off places,

Rebecca Suskauer

I could reach out to people
That most men would never dare to.
I can fly,
And I can try
To change the heart and mind of someone
Before all common sense dies.

Give me the chance,
Or I will *make* myself the chance.
Because if you won't give me the opportunity,
I will still be the best that I can be.
Because I'm a *woman*.
I play like a girl.
And I will play my woman's card to make a change.
So *deal* with it.

Becca Suskauer is a 12th-grade theatre major who attends Alexander W. Dreyfoos School of the Arts. She is proud to be a feminist, fighting for her equal rights every day through speech and through writing and social media. Our movement has been tested in this past election, and even with a surprising outcome and an uproar of harassment and hate crimes happening nationally, the feminist movement is stronger than ever, and we will fight for our rights and for the good of this country.

Anonymous

Overall feminism means everyone should be treated equal. But that does not always happen. Everyone has the same rights no matter if they are a man or a woman.

Fairness
Equality
Make a difference
Independence
Nice
Inspirational
Support
Mindfulness

This poem is about equality and feminism.

Anonymous

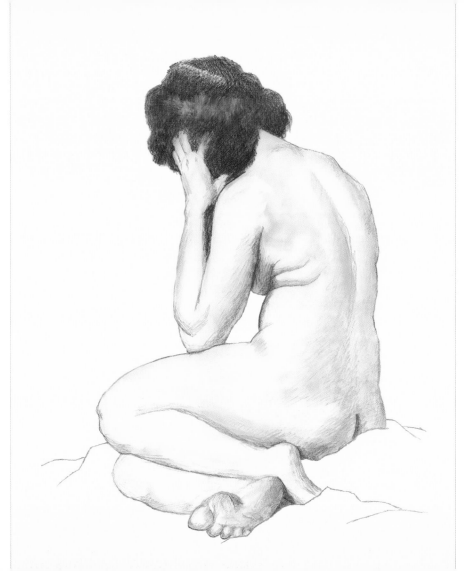

Jessica Beckenbach is a student at Savannah College of Art and Design. When not working on her art, she is usually found sleeping on the most convenient surface surrounded by empty bottles of tea. After one of her friends was raped, she realized that true safe spaces are few and far between. This is one of a series of images depicting the trauma and aftermath of rape. The scars are internal and long lasting, and she wishes the experience upon no one.

Jessica Beckenbach

Elle Buckley

I was invisible for the longest time
Standing there
in the shadows of men
I felt used
Like a squeezed-out orange
Deprived from all of life
Standing there
like a rag doll
Just there to look pretty next to him
No real purpose
No existence
Empty

Now I have a purpose
My existence has been brought back
reincarnated
Forever fulfilled
In this fight
for
Freedom
Equality
Power
Hope
I am a suffragette.

*Elle Buckley is a freshman at
Grandview Preparatory School. She
wrote this in 7th grade.*

Hunter Davis is a senior at Grandview Preparatory School and enjoys studying history. He has gone to school in California, Singapore, and Cambodia and hopes to go to college overseas.

Men and women should be equal,
sexism doesn't need a sequel.
We should empower all the girls,
whether their hair is straight or has curls
Let's support this movement together
If it is sunny or bad weather.

Hunter Davis

Izzy Cohen is 8 years old and in the 3rd grade at Grandview Preparatory School. She loves art, dancing, and singing.

Fair
Equality
Making changes
Inspiring
New life
Intelligent
Strong
Made to improve the world

Izzy Cohen

Zoe Cohen

Feminism means men are not always stronger or better at most things. Feminism means that women and men get treated equally at work. Feminism means to be strong, kind, and treat people equally just as people should do to women.

Zoe Cohen is in 5th grade and is 11 years old. She goes to Grandview Preparatory School and loves it there. She likes art, reading, and playing volleyball.

María José Garcia Rivas

María José Garcia Rivas is 19 years old and born in Tegucigalpa, Honduras. Her father, Santiago, her mother Gricelda, her sister, María Fernanda and her grandmother, Marina, have been great influences in her life. She has received her studies in Delcampo School. Trilingual, and winner of several debate and public speaking competitions, she is a young woman with hopes of using her skills for changing her country and the world for the better.

Amanda stared at her screen, wondering why she hadn't closed the tab yet. Her eyes roamed the words plastered on her computer and held the urge to sigh. She couldn't understand why she tortured herself with it. She knew it wasn't meant for her.

The living proof of that stood laughing freely with some hotshot client in the office in front of her. Oh, how she wanted to walk up to the men and tell them she was the most capable lawyer the company had ever seen.

But she knew she couldn't do it, especially after she had applied, just a couple of months ago, to that exact position the other man holds. It still stung, she couldn't deny it. She had been applying and waiting to hold a higher position in the company for the past 4 years now. And no matter what she did she always ended with a broken ego and sitting in the same small office she has had since the first day she had arrived at the company. Amanda glared at her screen.

The email seemed to mock her, to show her what she will never achieve. She could smell the promotion, just waiting for someone to grab it but she didn't dare to be the one to do it anymore. Right?

If she couldn't win the promotion to be the head lawyer handling the operations of the brand here in New Jersey why would she think she would be the one to handle the expansion of the company to New York?

Just as she was considering the small possibility of actually going to the interview tomorrow, her office door banged open.

"Don't even consider it." Amanda knew that voice very well. It had been the voice of every advice she had heard and followed since her college days.

"Well, hello to you too, Sophie." Amanda smiled at her best friend as she smoothly closed the tab that portrayed the promotion she deep, deep inside wanted. She lifted her gaze only to find Sophie glaring at her.

"I know what you're thinking and I know it won't go well." Amanda shook her head and laughed trying to hide how her heart dropped as she heard those words. Maybe she held a little hope to go after the promotion after all.

"I don't know what you're talking about." Amanda diverted her gaze from the inquisitive eyes of her best friend. Trying to ignore Sophie, Amanda pulled a high pile of folders filled with documents and started sorting them out. She clenched her hands and straightened her back; she had a lot of work to do either way.

"Oh no, no, no." Sophie walked up to her and put her hands on the desk. "I know you want to go for the promotion! Don't try to deny it!" Amanda bit her lip, slowly lifted her gaze and looked at Sophie with soft, defeated eyes. She couldn't understand why she was never good enough to aim for more... to be more. She knew she was capable. Why couldn't other people see it?

"Look," Sophie's tone softened. "I don't want to discourage you but I don't want to see you

get hurt again. You've been applying for promotions for the past 4 years and you always lose to some man with half your skills. You don't need that anymore."

Amanda tapped her nails against her desk trying not to let Sophie see how each rejection affected her, not only professionally but as a human being as well. She was so done trying and trying and never achieving anything. Amanda peeked a look behind Sophie and her throat constricted as she saw the office before her. She couldn't believe that man had won the promotion over her and now was dealing with one of the most important people in the entire state. Amanda sighed in discontent.

"Come on, Sophie, don't start with those conspiracy theories about how I'm rejected for being a woman. It's the 21st century. That doesn't happen anymore." Amanda rolled her eyes. Sophie was kind enough to come up with all these theories to make me feel better.

"These are not theories Amanda. A couple of months ago you lost to Roy, the year before that Martin, the year before that Sebastian and the year before that Carlos." Sophie crossed her arms across her chest and sat before Amanda.

"You are more capable than all those men together. Literally," Sophie grabbed one of the folders on Amanda's desk and snapped it open. "You are still doing Roy's work without taking any of the credit. Stop doing this to yourself."

Amanda closed the folder and shrugged her shoulders. "He's my boss now Sophie and I'm not doing anything to myself. I simply won't apply, don't worry about me." Amanda's voice was steady and nonchalant, giving Sophie peace of mind but deep inside Amanda just couldn't wait to go home and stop thinking about it.

● ● ●

The next day Amanda had no desire whatsoever to go to work. She couldn't help but feel so frustrated with everything happening in her life. She was successful, she knew it. She was living

comfortably, and had enough income to buy her necessities and indulge once in a while but she wanted more. Amanda knew she was smart and creative and was willing to work twice as hard to make things happen. She had worked through high school to help her parents pay the bills and still managed to be valedictorian when she graduated.

Being the first one in her family to go to college, she had no idea what she had to do but she didn't let that deter her. She worked three jobs to pay her tuition and loans and managed to graduate with honors. Amanda went to law school and managed to graduate against all odds. She could still remember when she scored her first job, how her mother's eyes watered and her father hugged her with so much force she could barely breathe. That day had signified the start of a path filled with greatness. A path that had been nothing but a fantasy. She has been stuck in the same place for the last 8 years with no prospects of moving forward.

She cast her eyes down and bit her lip, feeling somehow guilty for whining when she had been so blessed. How could she want more when some people around the world had barely enough to live? It seemed as if the universe had heard her heart struggling because right that moment her phone flashed, signaling a call she somehow knew she needed.

"Hey mom," Amanda greeted, a genuine smile invading her features.

"Hi sweetie, how are you?" Her mother's soft, melodic voice warmed her being, enveloping her like a warm blanket in a harsh winter storm.

"I'm good." Amanda sounded way more cheerful than she was supposed to which instantly tipped her mother off that something was not right.

"What's wrong Amanda? And don't you dare lie to me, I'm your mother." Amanda played with her fingers and debated whether or not to tell her what was going on in her mind. She didn't want to sound ungrateful about the job she had but there was something inside her, a fire that wanted to come out but no one had ever given her the opportunity to show it.

"There's a promotion at my job-"

"Oh, great! You're applying right?" Her mother's excited tone made Amanda feel worse about the situation. "Umm... not exactly," she corrected. It wasn't necessary for her mother to say another word because Amanda already knew she was beyond shocked and, to a certain extent, confused.

"How come?" her mother asked tentatively, trying to understand what was going through Amanda's head before judging her daughter's decision.

"Mom, I have been rejected the last four times I have applied. This time it won't be any different. I'm just saving myself the trouble of going through another rejection." Amanda shrugged and tried to smile as she said that to the woman who had raised her. Maybe her mother would understand why she didn't want to go to the interview... well at least she hoped so.

"Amanda Johnson, please tell me you do not mean what you just said." With trembling hands, Amanda took a strand of her hair and tucked it behind her ear. She was about to respond when her mother's disappointed voice rang through the phone.

"In your high school days, when we barely had enough to eat, people said the most you could aspire to be was a waitress. In college, drowned in loans, people said you should just drop out and try to find whatever job could put you through the day." Amanda could imagine her mother pacing through the living room while debating whether or not to drive all the way here to knock some sense into her.

"Rejections do not define who you are. They just make you stronger for the next time. If you do not want to apply then I will support you. But if you do it because you fear you will fail then I haven't taught you anything." Amanda's eyes watered and she looked down at her lap. Was she really wrong for wrong for fearing another rejection? She was just so tired of having the opportunity right in front of her, right at the reach of her fingertips and never being able to actually grab it.

"Conformism is not good, sweetie. You are made for so much more. Just give yourself another chance." Sporting a lump in her throat, Amanda nodded and assured her mother she would think about it.

With that thought in mind, she went to work. As she neared the small office that had held her wishes of a brighter future, a thought invaded her mind. Before she changed her mind, she grabbed a couple of documents from her desk and walked toward the office where the interviews were going to be held. Just like her, four other men sat, waiting to be called. As the only woman sitting there, she could see in their eyes that they didn't think she was a threat. And no, this was not paranoia from Sophie's words invading her mind. Amanda could infer it considering they only glanced at her and continued their conversation. Her brows furrowed and her lips pursed. Their eyes only fueled her want to gain this promotion and be better every single day. Time went by and name after name was called. Finally, after an eternity her name was called. Standing on shaky legs, Amanda walked toward the office, trying to maintain a calm face and confident posture. As she closed the door and approached the four men sitting on the conference table, she could finally distinguish who they were. Shocked, she gulped and tried not to show how incredibly intimidated she was. There, standing in all his suited glory, was the CEO of the company and sitting around him were the investors who have contributed the most to the development of the company.

Amanda smiled and introduced herself. Their cold gazes seem to scorch her soul but hearing her mother's words repeat themselves again in her mind, she lifted her gaze and went for it. She answered their questions as capable as she could. At first, she was nervous, she couldn't deny it. But as they started with their inquiries regarding the investments and the approach she would have with the funds, she started to be comfortable. Amanda started speaking more freely to the certain extent she began to give bold propositions she had kept to herself for the past years.

As soon as she finished one of the boldest programs she wanted to integrate, the CEO rose to his feet and walk toward her. "Ms. Johnson, I must say I am impressed." He seemed to

circle her as if trying to figure her out. Amanda shook in her heels as she heard the tone of his voice. She closed her eyes for a second, dreading to hear a 'but' in his next sentence. She looked at him and prayed to the heavens to please just give her a chance.

"Congratulations Ms. Johnson, welcome to the New York team."

Amanda's eyes widened in shock and her mouth unprofessionally fell open. She closed her mouth and shook her head. "Are you serious?" Amanda held the urge to screech in disbelief.

"Of course Ms. Johnson. I'm afraid I have other appointments and I must leave, but if you have any doubts do not hesitate to email me." With that he stood, telling her in a silent sign that she was dismissed. Trembling, she grabbed her documents and walked toward the door. Just as she was to step out, the CEO stopped her. "Just a piece of advice, try to be more confident." His comment brushed her the wrong way, and with confidence, she did not know where it was coming from, she turned toward him and glared. Amanda was sure if she were a man, he wouldn't have said that to her.

"Excuse me," she said, unable to hide her annoyance.

The CEO threw her a warm smile. "We need more women like you in this company and we wish that more will follow your footsteps. The investors and I believe, that with you on board in such a big project, the company will have the greatest success we have had so far." And with that final statement, he left her dumbfounded. As she walked victoriously out of that office, she couldn't help but think.

Thank you, mom. Thanks to you, I'm reaching further.

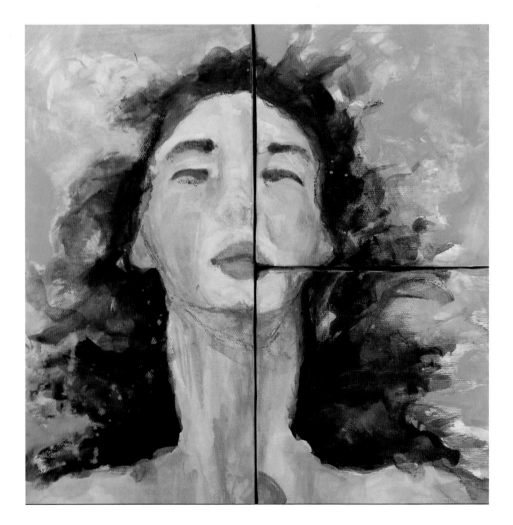

Maurya MacDonald

Serenity was the essence of this piece. Its surroundings, although perceived as different things, should instill a calm essence to its audience. Self empowerment can be seen right side up through the gravity of the piece, as well as the serenity of floating in water when the piece is flipped upside down. This piece isn't solely about its creator's feelings but that of its audience most importantly.

Anonymous

Feminism to me means equality
for all, there is a negative
thought around feminism

because most people think
that feminism is for women to
become more powerful than
men but it just means equal pay,
rights and a way to live.

9th grade, believes in equality for everyone.

Jolie Emma Bershad is 9 years old and likes to dance, sing, and act.

I think both men and women should be equal and should have the same exact rights.

Jolie Emma Bershad

"May Woman Rule The World"

— Kurt Cobain

Junior. A fan of veganism and feminism.
The meaning of my quote is to show the strength a quote can have
in just 5 words.

María José Pinzón

María José Pinzón was born in Bogota, Colombia. In Latin America, gender roles are still very cemented in society. She is not someone who believes anyone should follow the norm if they don't want to. Partly due to religious reasons and culture, the Latinx mindset can sometimes be closed-minded to marginalized people and change in general. María tries in her everyday life to incorporate a change in small, manageable portions to the people around her so we can hopefully all evolve as humans together.

RAISE

wo neatly flowing channels, both filled with babies. One is fur-lined and painted light pink, the color of blooming azaleas; the air smells of vanilla and cherry candies. The atmosphere inside is emotion-filled, it sounds like crying and laughter all at the same time, but not obnoxious, never obnoxious. If you listen very closely, you can even hear faint apologizing for all the fuss. The other is covered in sky-blue paint. It doesn't have a particularly pleasant smell. A fragrance boutique would label it as "pure sport" or "noir". There is silence, the air thick with the absence of familiarity and trust. Only knowing glances of mutual understanding of the unspoken pact are exchanged.

You are in the pre-life. Girls and boys are categorized into the paths their lives are going to take based on their genetic makeup. As soon as they're born, they're promptly transported to a nursery that graciously matches the color of their pre-life channel. Girls are given gorgeous, gemmed gowns to dance around to the beat of ball tunes while boys are given balls to throw around.

Dolls, castles, baking utensils, small brooms, fashionista kits, nail polish, soft hair brushes, makeup sets. Swords, play guns, dinosaurs, toy cars, skateboards. As life progresses, twisting and turning at its own will, girls continue to sit pretty through school. They have made their graceful transition from plastic lipstick to rich, waxy lip rouges; they wear blouses with light skirts that seem to always be majestically flying with the wind, calling for that troublesome attention that forces a quick hand to catch the fabric mid-air. Boys are constantly distracted by these magical, almost mythical, creatures and their mysterious bodies. An exposed shoulder, painted nails on dainty hands, bare knees, soft, long hair; it is all far too much. They must focus on their future during school while also trapping their vague emotions within their pubescent minds and questionably-their hearts. It is okay for girls' minds to wander during their studies, however, considering their ultimate goal is to achieve marriage and summon babies of their own from the pre-life channels so they can give them their endless affection

and care. They get to show off their relevant assets during dances and lively social events, where they can ultimately fulfill their impending destiny as a mother and wife, materialized in the shape of a boy, realized only through the partnership this boy can provide. Even bonded together through matrimony, even as women and men, they couldn't be any more distinct from each other. The women, now happily making another transition in identity as in the past: from daughter to wife to mother, they work as they've never worked before to raise achieving young boys and stunning young girls in a way only they know how to do. The men, on the other hand, work tirelessly every day in order to bring money back home to feed those achieving young boys and stunning young girls so as to fill their own charged inner silence with external satisfaction. These pre-life predetermined duties are to be executed until the day they go into eternal rest, to the afterlife and back to the pre-life.

Peculiarly, and to the amazement of the pre-life headquarters, the gendered channels have begun to change, to merge, to become... one channel. It happened only recently. It was something in life that caused it, a feeling of transcendence and of visions of life existing, pre-existing, and post-existing beyond binaries. It happened without warning. Reports dictate that a blue ball recently bounced from the blue channel to the pink channel. The baby girls, instead of repelling the ball with stifled squeals of fear, engaged with the ball with curiosity and refused to give it back. Conversely, a pink pegasus flew with its tiny wings over to the blue channel. Surprisingly, some of the babies timidly walked up to the strange creature, eventually shrieking with joy as they teased and rode the pegasus in circles through the channel. In life, stereotypes are being challenged with brand new ideas, such as androgyny and gender fluidity. Researchers believe this modern way of thinking is leading people to raise girls and boys in the same manner, forcing the pre-life channels' natural pathways to absorb one another to satisfy the recent will of life. This has blurred the line between both genders, giving the child more space to grow into their own skin. This change proves that every minor detail counts towards the direction of the future: a more welcoming and convivial place for everyone and anyone.

Any questions?

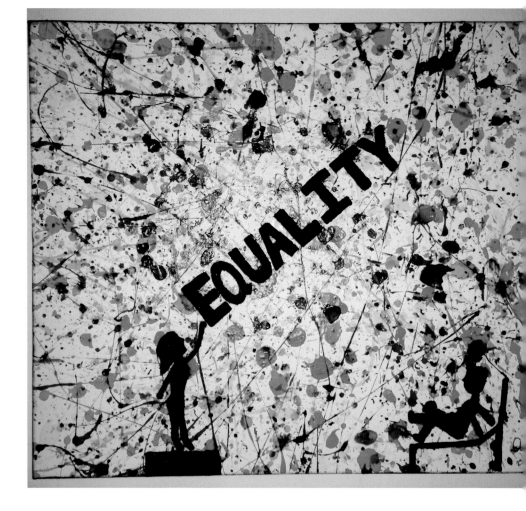

Andrea Herrera

Andrea Herrera created this piece because she dreamed of a world where men and women are treated as equals. Although there have been major changes throughout time, the world still can be a better place. Men and women need each other on a daily basis. The world needs justice and equality, so she wanted to represent that together we can achieve it.

Gayatri Khatwani

Gayatri Khatwani grew up having a powerful mother as her inspiration for an inclination towards feminism. Having traveled all around the world, she has observed the roles of females and the attitudes towards them in different societies. This piece is a poem including her profound realizations regarding feminism. She chose to create this in the hope that feminism is redefined as a movement which appreciates women for who they truly are.

ON WOMEN

Dedicated to my mother: a warrior for feminism.

It's strange. The attitudes towards women.
Here we are, fighting for equality.
So many feminist movements, so many lives changed -
Bras burned, thousands joined in protest, changes demanded in unfair laws,
Yet we are still so far from our goal: equality.
For a long time I have pondered over this, asking myself,
If there are so many people in this world empowering and fighting for women,
Then why do I feel so powerless?
The more I have thought about this
The more I have started to analyze everything and everyone around me
Meticulously, carefully, keenly.
I observe my father's influence over my brothers,
My mother's influence over me.
Conclusion:
Women are virtuous.
We are intelligent.
We are amazing.
We have the ability to give life;
Many of us are born with artistic ability.
We have the power to seduce men.
(We are) Appreciated for beauty.
I must stress, women are so beautiful.
Goddesses: worshipped for fertility, wisdom, and beauty,
Determination, selflessness, and sacrifice.
If women are so virtuous and honored,
Why aren't we all treated like queens?

The most divine virtue in a woman is compassion.
Compassion - the ability to love someone so dearly as
To feel what they are feeling in any situation,
To comfort them in times of need,
Be it a lost child on the street looking for his mother
Or a close friend struggling with depression.
Sons look to mothers, spouses to spouse, siblings to sisters, friends to friend.
Unfortunately, this sense of compassion is often called "weakness".
To those who think a woman breaks easily
When she is faced with the pain and loneliness of others,
Why shouldn't she break?
Pain and loneliness may not be visible,
But they put on a great burden
On those who are compassionate enough to carry it.

Albeit this belittling view of compassion in women,
We can change people's lives,
Make an impression
For even as restricted as we are, we are powerful.
Feminism isn't just about breaking all restrictions,
It's about having people acknowledge these virtues,
For the acknowledgment of these virtues will change attitudes towards women.
Feminism is about teaching girls and women of their power.
With such virtuous qualities and
Such abilities to change people
Women are running the world,
Allowing everything and everyone to function properly,
To keep their loved ones happy.
The only problem:

When a woman sets out to fulfill a dream,
After having sacrificed so much,
Given her compassion so wholeheartedly,
Those who have received these gifts
Are the same ones who push her back.
What we need is a realization of a woman's
Perseverance:
We battled and will battle.
Every step on the battlefield
Manifests our valor and tenacity.
Our swords, slashing and clashing,
Are our unfaltering strength against all that drags us down.
Simultaneously, we raise our shields
To protect ourselves when all abandon us.
Our battle cries echo the voices of the thousands of women
Who are so fearless as to never renounce their goal.
Although we are fighting giants,
Our undying passion will not go in vain,
For the virtues we possess
Are only signs of victory.

Sofia Gonzalez

Sofia Gonzalez is a teenager from Caracas, Venezuela. She moved to Panama six years ago but lived in Mexico for a semester last year. As a teenager surrounded by teenagers, she has experienced and heard stories about catcalling and harassment. The most surprising thing about these stories is not the fact that they are being told by extremely young girls, but that the harassment often comes from adults. One of her passions is writing, and she hopes that through this story people can get to experience what a teenage girl goes through when she is being catcalled, and how such an event can completely change the way she looks at herself in the mirror.

THROUGH THE EYES OF A TEENAGE GIRL

Sarah opened the closet door looking for the dress she had bought weeks ago. It was a beautiful dress: lace, black, tight, and short (according to her mother). When she found it on the sales rack, she had almost convinced herself not to buy it as she had really no good use for such a fancy dress, but her friend Chantal had told her to try it on for fun since she hadn't picked out any other clothing item to buy. Sarah, unlike Chantal, always had a hard time finding clothes that fit her well. She always struggled with accepting her body as it was and wearing her clothes with enough confidence. She had taken the dress to the fitting room, hiding it behind her, scared that anyone would judge her for believing she would look good in such a dress. At that moment, she had closed her eyes, taken a deep breath, and thought of what she would tell Chantal when she had to put the dress back. She had opened her eyes, expecting to see her usual self, wrapped in a horrendous piece of fabric, but was surprised to see a different person. It was her. It was the same body she constantly degraded in her mind. Yet, in that moment, with that dress, she felt powerful. She felt secure. She felt confident of her own body. She wondered how such an insignificant item could change everything for a person. Here was Sarah. Sarah who didn't look down when she was walking on the street. Sarah who believed in herself. Sarah who, suddenly, was the queen of her own world. It had been then that she decided to buy the dress even if she never actually wore it in public. She wanted it as a reminder of what she had felt at that moment when she had looked in the mirror. She wanted a remainder of the Sarah she hoped to be. Little did she know one day she would get the chance to wear it to the biggest party of the year. The day arrived slowly. Sarah grabbed the dress from the hanger, ran to the bathroom, and quickly put it on, feeling the confidence invade her body like magic. She then ran to the kitchen, the exhilaration pouring from her. Her mom was making breakfast, her eyes widened when she saw her young daughter in what she thought to be a very revealing dress. "How do I look?" Sarah asked, impatiently.

"Mmm.... wow. I don't know what to say. Are you wearing a jacket over that?" Sarah's mom asked.

"I wasn't planning on it, why?" Sarah said, annoyed at her mom's old-fashioned ideas.

"Oh... I just think you should because that's too revealing. You have to be careful with boys your age and showing that much cleavage," responded Sarah's mom.

"What do you want me to wear then, a skirt down to my ankles? You know what, never mind." Sarah's mom went back to preparing breakfast, and Sarah ran to the bathroom to look at the dress one more time. Maybe her mom was right. Perhaps it was too revealing. She looked again and again but saw nothing wrong with the dress. She was still going to wear that dress later that day no matter what her mom said or thought. This was her chance to feel, for once, confident.

Later that day, Sarah curled her hair, put some makeup on, and let herself get carried away by the feeling the dress provided her with. That feeling of control. Control over her own body. Something she had desperately desired ever since she could remember. A smile crept on her face. In the bathroom, alone, she gave a few turns and laughed, her hair flying behind her. This was all she wanted, and nothing, absolutely nothing, could ruin this moment of joy for her.

Sarah decided to walk to the party. She didn't want her mom nagging her in the car to tell her to cover herself like she had done during breakfast. She was going to Chantal's house, and her mom would give them a ride to the party. Chantal's house was two blocks away. It was a new neighborhood, so most of the houses were under construction. Sarah decided to leave the house early, that way she and Chantal could watch a movie and get dinner before the party. As she was walking, she felt the soft breeze blow her curled hair across her face. For the first time, she wasn't looking at her shoes. Now, with just the company of the setting sun and the chirping birds, she walked with her head up, not caring if her hair got in the way of her vision. She kept walking, enjoying the sound her boots made with every step she took. As

she approached one of the busy constructions by the end of the street, she noticed one of the workers looking oddly at her. It was a middle-aged man slouching against one of the walls he was building, smoking a cigarette. Her first instinct was to pull her dress down and look at the floor. As she kept walking she felt tense, all the confidence rapidly disappearing. The man whistled. A demeaning kind of whistle that made Sarah's skin prickle. She walked faster, wrapping her bare arms around her body to create a shield that would protect her from the wandering eyes of the stranger. Her mind was racing, all of her mother's warnings about men and all of the stories she had seen on social media about encounters on dark alleys suddenly took over her thoughts. Sarah walked a few more steps before she saw a pair of brown boots in front of her, blocking the way. Her lips quivered, her body now shaking even though the air around her was hot. She looked up at the owner of the boots and saw that it was another one of the construction workers, a broad man looking down not at her face or eyes, but at something else. Sarah pressed her lips together to stop some of the shaking. She thought of all the possible outcomes of this situation. The worst. The best. Neither seemed appealing.

The man kept examining her and once she made up her mind to go around him, he stopped her, reached for her arm, stroked it, sending chills down her entire body, and whispered, "Where are you going with such a lovely outfit? You could stay here with us. We could have so much fun together." At that moment, everything came crashing down for Sarah. His touch. His hoarse voice and sweaty smell. That comment, those words that made her so angry yet so vulnerable, destroyed all of the self-confidence she had just a few minutes before. She went around him, tears of disgust running down her face. She ran, not looking back, picturing Chantal's house a few meters away. Even as she ran, pulling her dress down and wrapping her arms tighter around herself, she could feel the stares and hear the whistles behind her. Perhaps she was imagining it. It didn't matter. She wanted to take the dress off and throw it away. The moment in the mirror was gone, as was the Sarah she had been when she had left the house. Her heart was beating faster than she realized as she approached Chantal's house. She would be with her friend in a few seconds. With her brave friend who would embrace her and reassure her that everything would be okay. She would feel safe again. Just like she had felt safe in the dress. This time, she thought, it wouldn't disappear so quickly.

A tiny shimmer of hope floated in the back of her mind as she rang the doorbell, the tears still streaming down her cheeks.

Chantal opened the door. Her hair was half straightened and she was holding a brush on one hand. She looked at Sarah in shock, she had never seen her cry before. Sarah let out a breath she didn't know she was holding and started sobbing into Chantal's arms. Chantal patted Sarah's hair awkwardly, trying to calm her down. They went inside and sat on Chantal's bed.

"What happened?" Chantal asked, intrigued but also extremely worried.

"It's... they.... The workers.... I am... please..." Sarah babbled. A few minutes later, once Sarah had calmed down, she told Chantal what had happened. As she repeated the incident, the man's voice kept invading her, the spot where he had touched her now seemed to be foreign. The dress. That beautiful piece of clothing that had made her feel secure for the first time became a meager piece of black fabric covering her body. As she told Chantal her story, Sarah watched for her reaction, expecting nothing but support from her best friend. Chantal's reaction, however, was the opposite. She laughed, calling Sarah a "drama queen" and an "attention-seeker." She had said to Sarah: "That's what men do. You should take it as a compliment that they even bothered to look at you."

Sarah nodded and pretended to laugh. When it was time to go to the party she told Chantal she wasn't feeling well and called mom to pick her up. Chantal didn't argue, she just rolled her eyes and scoffed. This wasn't a friend, Sarah thought. Because for her, the experience in that lonely street had been horrific. She had felt degraded. Disgusted. Dirty. Her flaws were exposed. Her confidence was shattered. No one could understand what she had felt. That experience had changed her, she just hadn't decided if it was for the good or for the bad. At that moment, the doorbell rang, interrupting Sarah's thoughts. It was her mother.

They got in the car silently, Sarah still pondering how she was going to tell her mom about what had happened. Thankfully, she didn't ask any questions.

During the car ride, Sarah's mind wandered again to the event. As she looked out the window, the air conditioner blowing cold air softly at her face, she imagined a perfect world. A world where women were truly considered equal to men. A world where a woman was a human being with feelings and emotions and not a sexual object made to please men. A world where a girl could wear any article of clothing that made her confident without having to worry about any inappropriate behavior. She then imagined a world in which women would stand up for themselves in such situations. A world where they would demand to be respected and not just say "It's what men do." A world in which she, like every other girl, could walk with her head up, hair flying behind her, not a care in the world, because in that world she would be treated as any other human being: with regard and empathy.

Sarah got out of the car and went to her room. She took off the dress and looked at it carefully. She thought of throwing it away. Or burning it. Then she thought of everything she had reflected about in the car, and she decided to keep it. Before she wanted it as a reminder of the Sarah she hoped to be. Now, it was a reminder of the experiences she was leaving behind. She looked in the mirror. That same mirror that had helped her engrave all of her flaws into her brain. This was the new Sarah. The one who was confident regardless of a dress or of a friend. The one who was secure and sure of herself because someone had to be if there was ever going to be a change in the world. That perfect world she had imagined. It could exist. There just needed to be people willing to sacrifice themselves for that change and people willing to change their way of thinking. She would wear the dress again when the time was right. Hopefully, thought Sarah, she could help a little girl somewhere whose fate was to end up on a lonely street on a way to a friend's house.

Ana Hentze

The theme of this work is to bring awareness to body image, self-body acceptance and try to end body shaming and the objectification of women. We are all beautiful in our own shapes and sizes. We are all equal.

Contributors

fem·i·nism

\ ˈfe-mə-ˌni-zəm \

noun

1 : the theory of the political, economic, and social
equality of the sexes

2 : organized activity on behalf of women's rights
and interests

synonyms: the women's movement, the
feminist movement, women's liberation, female
emancipation, women's rights; *informal* women's lib

"a longtime advocate of feminism"